Celtic Decorative Art

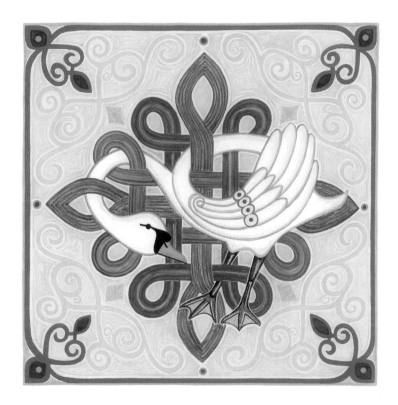

In Celtic times swans were a favourite form among shape-changers. One story involves a beautiful fairy called Cáer, who lived in the form of a swan but who eventually was wooed into human form by the god of love, Aonghus Óg. See Swan, page 62.

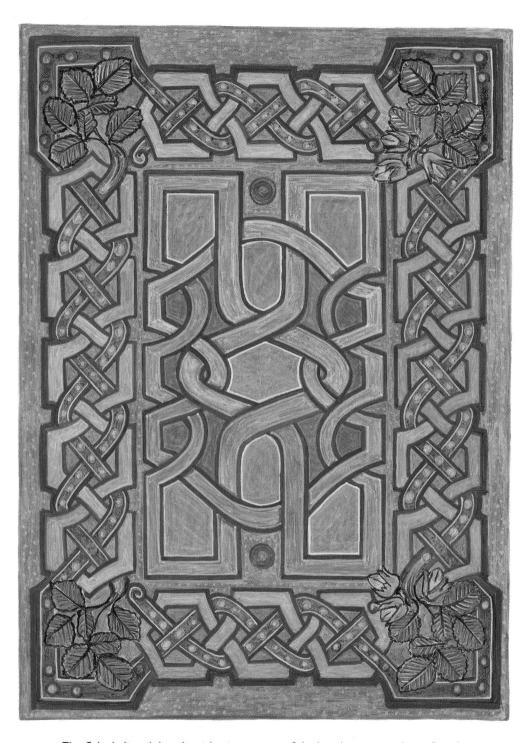

The Celts believed that the rich crimson nuts of the hazel tree not only conferred
wisdom on those who ate them but that the branches could also be used for
water-divining and for warding off evil spirits. See Hazel, page 33.

Celtic Decorative Art

A LIVING TRADITION

Deborah O'Brien

An Illustrated History of the Celts and their Art by
Mairéad Ashe FitzGerald

℘

THE O'BRIEN PRESS
DUBLIN

First published 2000 by The O'Brien Press Ltd,
20 Victoria Road, Dublin 6, Ireland.
Tel: +353 1 4923333; Fax: +353 1 4922777
E-mail: books@obrien.ie
Website: www.obrien.ie
Reprinted 2002, 2006.

ISBN-10: 0-86278-598-7
ISBN-13: 978-0-86278-598-7

British Library Cataloguing-in-Publication Data
O'Brien, Deborah
Celtic decorative art : a living tradition
1.Art, Celtic 2.Art, Celtic - History 3.Decoration and ornament, Celtic
I.Title II.FitzGerald, Mairéad Ashe
709.3'61

3 4 5 6 7 8 9 10
06 07 08 09 10

Editing, typesetting, layout and design:
The O'Brien Press Ltd and Deborah O'Brien
Illustrations: Deborah O'Brien
Printing: Stamford Press Pte Ltd (Singapore)

CONTENTS

PART I

An Illustrated History of the Celts and their Art
by Mairéad Ashe FitzGerald 7–22

PART II

The Designs
Introduction by Deborah O'Brien 23–27

PART III

Practical Applications 71–80

This book is dedicated to
Professor Lucy Charles

PART I

An Illustrated History of the Celts and their Art

Ancient People

Mention of the ancient Celts conjures up images of proud and fearless warriors; mysterious druids performing magical rites in sacred oak groves; scribes, poets and artisans; and powerful gods and goddesses.

The Celts were a deeply spiritual people and they lived with a constant awareness of the supernatural world. To them, the gods were a powerful presence everywhere in the mortal realm. Some deities had airy homes in the sky, others lurked in streams and rivers, while still others occupied the misty mountain-tops. The gods were notoriously fickle in their humours, and much time and effort was spent consulting them on all important matters and appeasing them when they were angry. To help them do this, the Celts had druids – a class of priests, magicians and soothsayers – whose sole responsibility was the correct practice of their ancient religion. With their secret learning, the druids knew the lucky and unlucky days, read omens and made sacrifices to the gods.

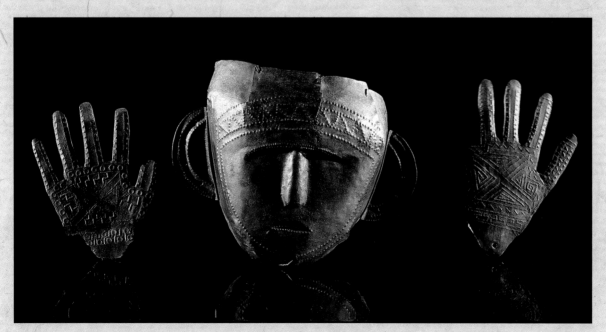

The mystery of the Otherworld is suggested in this Hallstatt bronze mask and hands, which come from a warrior burial at Klein-klein in Austria; 7th century BC.
(*Photograph: courtesy Steirmarkisches Landesmuseum Joanneum, Bild-und Tonarchiv, Graz.*)

An Ancient Tradition

Though much of the belief system of the ancient Celts may be lost to the continent of Europe, in Ireland – that most Celtic of countries – a great legacy of Celtic myth, storytelling and music lives on. For instance, one of Ireland's most ancient stories is the epic tale known as *Táin Bó Cuailgne* (*The Cattle Raid of Cooley*). Its vivid and sometimes gory depiction of an age-old Celtic warrior society of champions and druids, of witches and gods, and of warring kings and queens has been handed down through the centuries. It is a tale of jealousy, anger, pride, honour, betrayal and tragedy, and remains popular to this day. Similarly, Celtic places of worship on mountain-tops, such as Croagh Patrick in the west of Ireland, became places of pilgrimage in Christian times and remain centres of spirituality today. And, of course, the Celts left behind a legacy of great power, in an enduring and beautiful artwork style that has been adapting and changing for more than two millennia.

The term 'Celtic art' as we understand it today is applied to the mainly abstract interwoven style of ornamentation familiar to us from countless decorative objects. The meandering spirals, knots, elongated animals and countless elusive shapes weave endless patterns on embroidered fabrics, on wooden carvings, on stained glass and on stone. Deeply resonant with the Celtic mind and imagination, with its themes of infinity and metamorphosis, this art style nevertheless had its roots in Europe, where it was grafted with the art of the Classical World of Greece and of Etruria, where modern Italy is today.

Who were the Celts?

We must look far back in time to the millennium before Christ, the Central European Bronze Age, to trace the origins of the Celtic people. Much of the early story of these people is shrouded in mystery. The Celts were not a race or nation as we understand these terms today. They were, instead, a system of loosely connected tribes spread across Europe, who had language, material culture, religious beliefs and burial customs in common. Because they had not developed writing, the Celts have left us no accounts of their lives. However, by the time of the great migrations, the Classical authors of Greece and Rome were writing about them. They are referred to in Latin as Gauls, and Julius Cæsar (100–44 BC) tells us, 'In their own language they are called Celts, in our tongue, Gauls.' The early European Celts left elements of their tribal names across Europe, a testament to their wanderings before they emerged into the light of history. Thus, the word Paris,

for instance, is derived from the name of a tribe called the Parisii, Bologna from the Boii, who also gave their name to Bohemia. Lugudunum, the modern city of Lyons in France is named after the great Celtic god Lugh, who is still commemorated in Ireland in the festival of Lughnasa.

By 700 BC a culture known as Hallstatt had emerged. Named after the great Iron-Age cemetery near the Austrian salt-mines at Hallstatt, these Celtic people had developed their metal-working skills, especially the new and important technology of iron-working, and they were to play a great role in spreading this knowledge across Europe.

Inspiration from the Classical World

The Hallstatt Celts of the Iron Age traded on a massive scale with the Greeks and the Etruscans, exporting salt, iron and probably slaves. As a result, their princes became rich and powerful and we can see from their 'grave goods' – personal belongings that were buried with them – that they loved beautiful objects and that they enjoyed the good things in life, in particular, wine from the south.

Wine containers, such as painted jars, great bronze cauldrons, flagons and other exotic ornamental wares, found their way far north to the homes of Celtic chieftains.

The art of the Hallstatt Celts had a regular, rather geometric style, but the objects they imported, which were lavishly decorated with the art of the Classical World, were to bring a new vocabulary of design to the artists of the Celtic World.

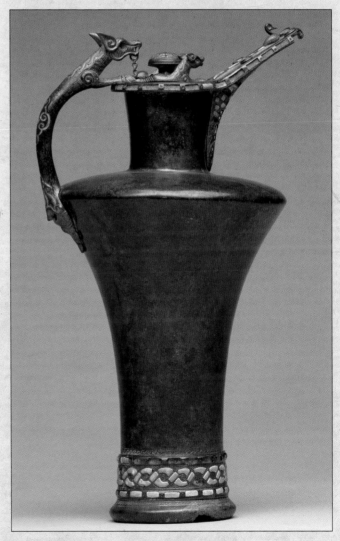

This lavishly decorated flagon, one of a pair, from Basse-Yutz in the Moselle area of France demonstrates the merging of the various influences which distinguish the art of the Celts. The tiny water-bird on the spout, the spiral-ornamented animals, the pseudo-human faces and the use of coral display the merging of Bronze Age, Hallstatt, Mediterranean and western Asian influences; late 5th century BC, Early La Tène. (Photograph: copyright British Museum.)

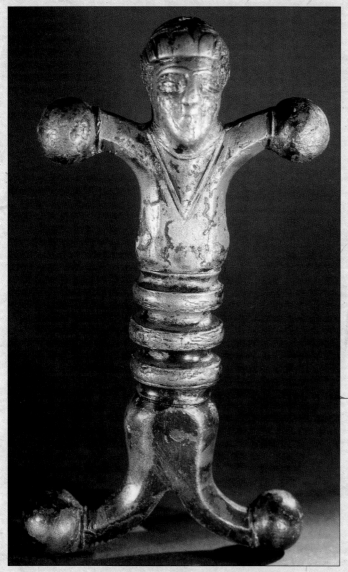

A link between Ireland and Europe. Found lost in the sea off Ballyshannon, County Donegal, this bronze sword hilt was probably made in Gaul in the 1st century BC. (*Photograph: National Museum of Ireland*.)

Warrior Celts: the Art of La Tène

But the story of the Celts, like that of other peoples, was to be one of change, of movement, of unpredictability. Around 400 BC, the Celts began to pour out from Central Europe in search of new lands and plunder. Huge migrations brought them into eastern Europe, to Italy, to Greece and to Asia Minor. In 387 BC, they sacked Rome and in 279 BC, Delphi fell before the onslaught. Although, for Rome particularly, these onslaughts were not as catastrophic as the later sackings of the fifth century, they still shook the Classical World to its foundations. Some of the Celts made their way to Ireland and Britain. Only the power of the Roman Empire spreading northwards subdued them but, because the Romans never reached Ireland, the Celtic ways lived on and flourished in this island while the Romans, and later the barbarian hordes from the East, overran the rest of Europe.

These were the La Tène Celts, a name derived from a site in Switzerland where thousands of artefacts, mainly weapons, were found in the last century. In order to appease or invoke the gods, the local Celts had thrown these objects into Lake Neuchâtel. The sword scabbards in particular are ornamented in a fine curvilinear abstract form of decoration. This La Tène style, as it is known, was predominant with local variations in all the Celtic lands from the Atlantic to the Black Sea, and its great beauty and originality has influenced Celtic art ever since.

The Celtic passion for wine maintained the links with the Mediterranean world, so trade with the south continued. This contact with the Classical World influenced the artistic work of the Celts. The art of the La Tène Celts shows fluidity and movement under the influence of the art of the south, very different from the rather geometric style of the Hallstatt Celts.

The plant motifs, the palmette (or tree of life), the acanthus, the lotus blossom and the vine tendrils, so beloved of the Greek and Etruscan artists, were borrowed

by the Celts, and modified plant shapes were to become part of the repertoire of their decorative art.

However, they were not attracted by the representational element that was so important to the southern artists. Not for them the paintings and statues of the human body, so dear to the Greeks and Romans, and not for them the telling of stories through art. The Celts had little interest in the representational or the narrative, but instead took the curvilinear elements and developed an art of imagination, of power and of beauty. As a result Celtic art is abstract, playful and mysterious.

Celtic art gives us an insight into the Celtic soul – the Celt who spoke in riddles, the Celt who lived in the shadowy world of the deep forest where light and shade played on the leaves.

The Classical inspiration for Celtic motifs is suggested here: (*left*) detail of 4th-century Greek red-figure acanthus ornament and (*right*) detail of 4th-century silver Celtic brooch from Schlosshalde, Kt. Bern, Switzerland. (*Drawing: courtesy J.V.S. Megaw & Ruth Megaw, after O.-H. Frey.*)

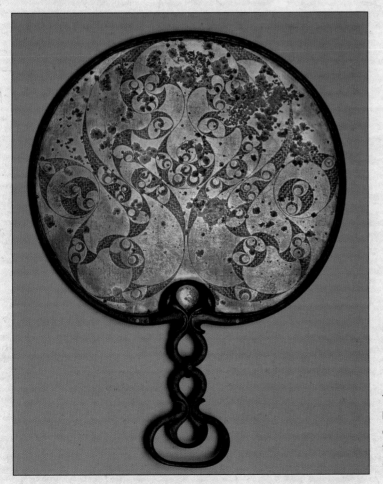

The playfulness of the Celtic artist lurks in the light and shade in the design of this British mirror-back from Desborough, Northants. (*Photograph: copyright British Museum.*)

CELTIC DECORATIVE ART

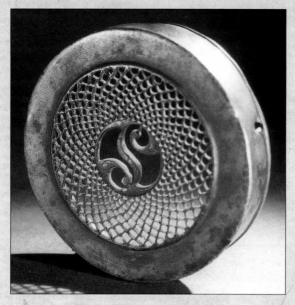

In Celtic art, nothing is as it appears to be. What seems to be a bunch of leaves has eyes peering out at us; what seems to be a bird appears at second glance to be an animal head. It is the art of the people of whom the Greek Posidonius wrote: 'They speak in riddles, hinting at things, leaving much to be understood.'

In this open-work bronze disc from Cornalaragh, County Monaghan, the background has been tooled away to reveal the symmetrical open-work design; 1st century BC.
(*Photograph: National Museum of Ireland.*)

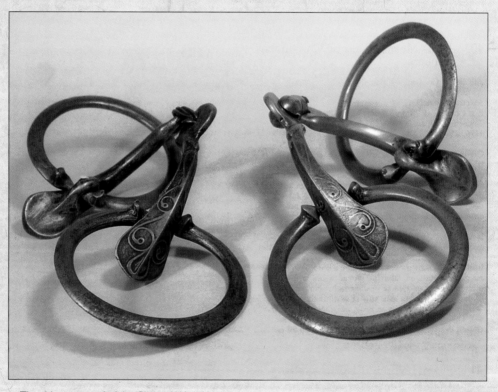

The palmette motif of the Classical World becomes the suggestion of a staring mask in the hands of the Celtic bronzesmith who made this horse-bit, found at Attymon, County Galway; 2nd or 3rd century.
(*Photograph: National Museum of Ireland.*)

A sense of the Otherworld was always present in the Celtic mind. The idea of the shape-changer, for instance, is a theme in our earliest myths and is expressed in our earliest stories. The idea of changing from one shape to another – from animal to bird, from human to animal – was to become a recurring theme in the great illustrations of the Gospels.

The art of the Celts was always intimately connected to the spiritual. The human head, for example, had deep magical and ritual meanings – the Celts believed the soul resided there. Meanwhile, the abstract meandering designs probably had a talismanic meaning, and were worn for protection. For example, Irish chieftains wore ornamented sword scabbards, and their horse-bits were delicately engraved in flowing abstract lines and graceful spirals. Chieftains, princes and princesses wore ornamented bracelets, finger-rings and neck-ornaments, known as torcs. They would also have lavished these designs on the daub walls of their houses for protection, and in the embroidery that gave colour to their cloaks.

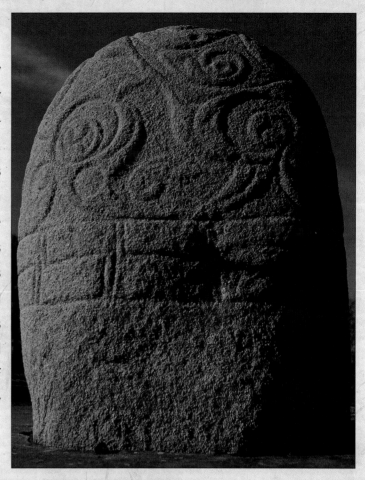

The Turoe Stone, 1st century BC. The surface of this standing stone at Turoe, County Galway, is covered with abstract curvilinear decoration in the La Tène style. It is one of five such decorated standing stones in Ireland. (Photograph: Robert Vance.)

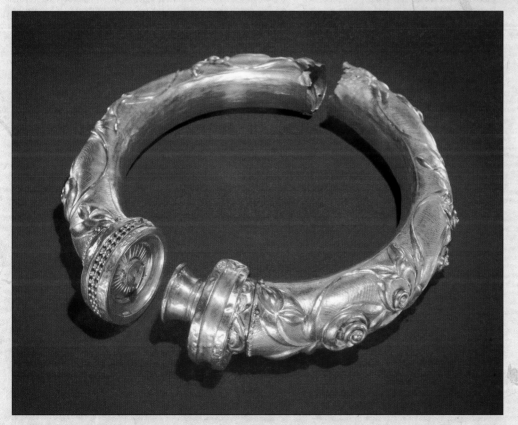

The Broighter Collar. Possibly an offering to the sea-god Manannán Mac Lir. Part of a hoard of magnificent gold objects found near the banks of Lough Foyle in County Derry. This tubular gold collar, dating from the 1st century BC, is one of the most outstanding pieces of European Celtic art. (Photograph: National Museum of Ireland.)

CELTIC DECORATIVE ART

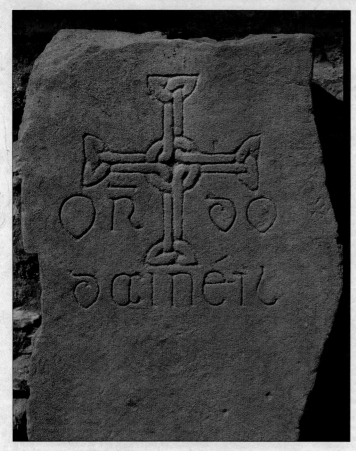

One of the many grave-slabs carrying memorial inscription OR DO ('pray for') from the early Christian monastery at Clonmacnoise, County Offaly.
(*Photograph: Robert Vance.*)

Celtic Christian Art

Ireland emerged into the light with the coming of Christianity, just as Europe was receding into the Dark Ages, ravaged by barbarians from the East.

Christianity was to bring new momentum and inspiration to the art of the Celtic Iron Age in Ireland, a time we still look back on as the Golden Age of Celtic culture. On the very edge of Europe, Ireland was isolated by the sea, and learning and art were nurtured and allowed to flourish there.

Always open to new influences, the Celtic mind now had a new medium to lavish its artistry on – the book. The smooth pages of vellum proved irresistible to the Irish scribe. One of our earliest manuscripts is the Cathach, a copy of the Gospels, which is believed to have been written by St Colmcille around AD 575. Although only the initial letters are ornamented on these pages, they are rendered in the same beautiful curving shapes that decorated brooches and other objects at this time.

The initial 'D' from the Cathach of St Colmcille (or Columba), a manuscript which dates from the late 6th century. The Cathach, with its purely Celtic designs, shows the tentative beginnings of what was to become the elaborate decorative tradition of the Irish illuminated manuscripts.
(*Photograph: Royal Irish Academy, folio 19a.*)

Book of Durrow. A new element in Celtic decorative art is illustrated here by the presence of interlaced animals found in Anglo-Saxon art. Celtic roundels and interlace from the Mediterranean indicate the diverse influences that nurtured the art of the Irish scribes.
(*Copyright Board of Trinity College, folio 192v.*)

From the early simplicity of the Cathach we see ever more fantastic artistry and rich colours developing over the next few centuries. The Book of Durrow, from the late seventh century, shows a further development, with the appearance of animals borrowed from Anglo-Saxon art in Britain. It is at this time, too, that the great painted initials are beginning to dominate the page.

Around this time Irish scribes started bringing their books to Britain and setting up monasteries in Iona and Lindisfarne. There was much to-ing and fro-ing of Irish scribes and scholars across the Irish Sea. Many young British students came to learn the art of the scribe in Ireland. Great and influential scriptoria were founded by the Irish at home and in Britain, such as that in Iona, an island off the coast of Scotland, which was founded by St Colmcille in AD 563. A most important offshoot of Iona was the monastery of Lindisfarne, where the great book of that name came to be written. The strange animals and fantastic birds of Anglo-Saxon art were combined with the old themes, the Celtic spirals, roundels and vine leaves. Interlace and knot-work from the Mediterranean world bordered the pages, in a style that is now known as the Insular Style.

What meanings did these symbols hold? Interlacing, a strong motif to this day, is thought to have been adapted by the early Christians as a representation of running water and probably carried the idea of fertility and the continuity of life. The ancient motifs from the Classical World – the vine leaves and scrolls and spirals – are thought to suggest an association with the power of the sun.

The Work of Angels

The Book of Kells is the most beautiful and the most renowned example of Celtic art of all time. It is a truly breathtaking piece of artistry. There are magnificent full-page portraits of Christ, of the Virgin and of the Evangelists. The playfulness so characteristic of Celtic art enlivens this wonderful book: cats, mice, hens and geese run and play through the text to amuse us.

The old Celtic *horror vacuui* is more in evidence here than ever – every corner of the page is crowded with designs. Giraldus Cambrensis, who visited Ireland in the twelfth century, was so enthralled by the beauty of the Book of Kells that he wrote of it:

> *You will make out intricacies, so delicate and subtle,*
> *so exact and compact, so full of knots and links,*
> *with colours so fresh and vivid that you might say*
> *that all this was the work of an angel and not of a man.*

CELTIC DECORATIVE ART

16

In other media, artists drew on the same artistic repertoire to create some of the greatest abstract art of all time. In metalwork, artists surpassed themselves in the sumptuousness of such objects as the Ardagh Chalice and the so-called Tara Brooch, while the designs they worked with are echoed on the magnificently carved High Crosses of the eighth and ninth centuries.

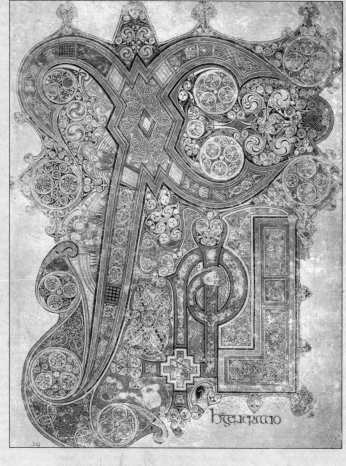

Book of Kells. The Chi-Ro page demonstrates the complexity and beauty of this masterpiece. The Book of Kells is the most ornate manuscript ever produced in the Celtic world. (*Copyright Board of Trinity College.*)

MEDIEVAL IRELAND: NEW INFLUENCES

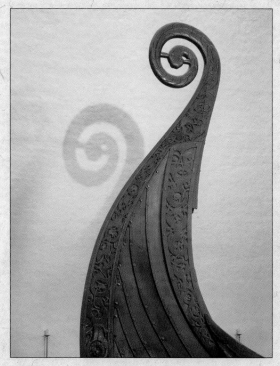

The ornamental stern of the Oseberg ship. Many of the artefacts found buried with this Viking ship show their affinity with the art of the Irish Celts. (*Photograph: Vikingskiphuset, Universitets Oldsaksamling, Oslo.*)

The arrival of Vikings in their longboats, beginning in the ninth century, brought profound cultural and social changes to life in Ireland. Celtic art survived the Viking invasions, and indeed Celt and Viking learned from each other so that scholars are still evaluating the influence each had on the other. It is generally believed that the beautiful carvings on churches, such as that at Urnes in Norway (which gave its name to an art style known as the Urnes Style), owes something to the contact of Viking

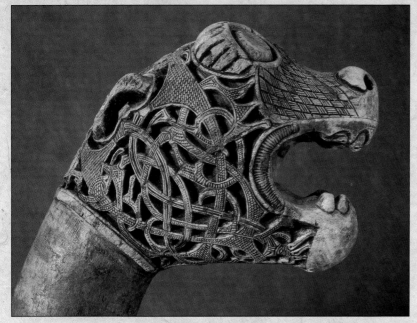

Detail of the carving on the head-post in the Oseberg find. (*Photograph: Vikingskiphuset, Universitets Oldsaksamling, Oslo.*)

craftsmen with their Irish counterparts.

Many Irish artefacts found their way to Scandanavian countries – Viking raiders were frequently buried in their home countries, with loot from Irish monasteries. The Oseberg ship-burial in Norway, for example, revealed, under a large mound, fragments of Irish metalwork, which indicates the close artistic links between these two cultures.

The reforming spirit of the twelfth-century Church in Ireland ushered in the new Romanesque architecture, the most remarkable example of which is Cormac's Chapel on the Rock of Cashel in County Tipperary. With the arrival of the Normans and religious Orders, such as the Cistercians, Dominicans and Franciscans, European trends in Romanesque and Gothic architecture began to take hold, but Celtic elements lived on. One good example of this is Mellifont Abbey, a twelfth-century Cistercian monastery in County Meath.

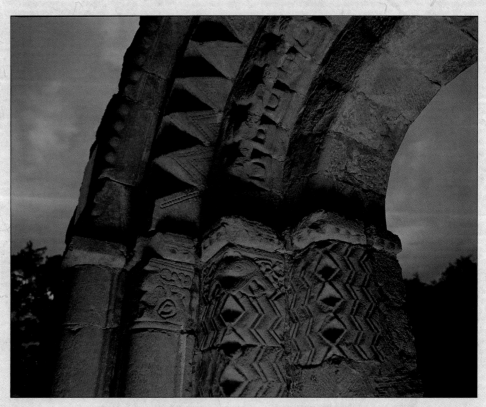

This detail of the West Doorway of the Nun's Church at Clonmacnoise demonstrates the Romanesque ornament of the early 12th century. (*Photograph: Robert Vance.*)

All through centuries of colonization the distinctive spirit of Celtic Art in Ireland lived on. It found expression in a new way with the founding of the Herald's Office in Dublin in 1552. This is one of seven such offices in the world today. The colour and symbolism of medieval pageantry associated with heraldry appealed to the Irish, and ancient symbols, such as the Red Hand, the boar and the deer, were incorporated into coats of arms for Irish families. These were of special importance to the legions of dispossessed Irish chieftains and their followers, who fought in all the armies of Europe in the seventeenth and eighteenth centuries. Indeed, to this day, the Herald's Office could be regarded as a School of Art, in that coats of arms are granted to individuals and corporate bodies.

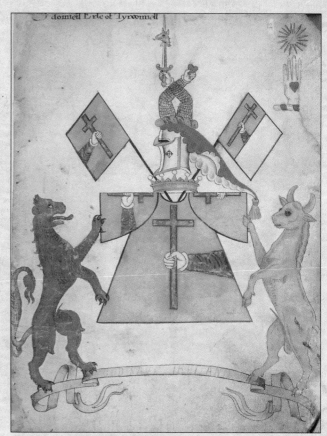

The arms of Rory O'Donnell, Earl of Tyrconnell, who died in Rome in 1608.
(*MS. 34, Office of the Chief Herald of Ireland.*)

The Art of the Revival

In the nineteenth century, Ireland, like many European countries, experienced a growing sense of national identity. Nationhood was growing as an idea and as something to strive for. Emblems became important.

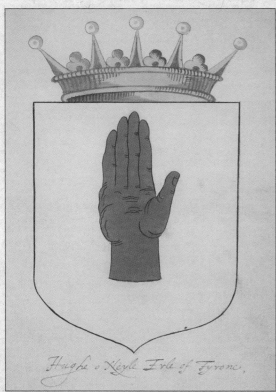

The arms of Hugh O'Neill, Earl of Tyrone, who died in Rome in 1616.
(*MS. 32, Office of the Chief Herald of Ireland.*)

All over Europe, people were looking to the medieval past for a sense of national identity. Ireland, looking back to the Golden Age before the incursions of the Vikings, found a new pride in her cultural past. The National Collection was getting underway, and the discovery of the eighth-century Ardagh Chalice, found in a potato-field in County

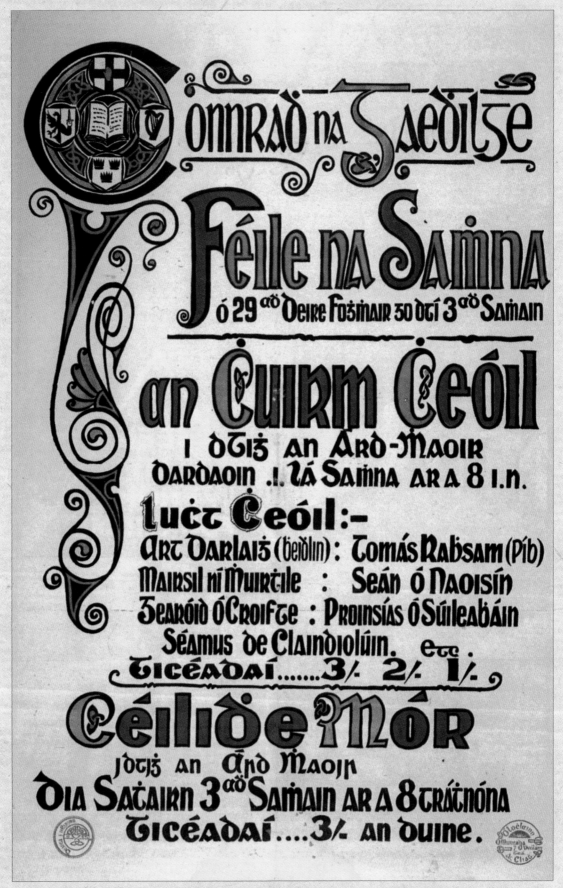

A poster issued by Conradh na Gaelige in 1917 for its annual Hallowe'en Festival, Feile na Samhna, features the ancient Irish scribal custom of ornamenting the initial letter. Here the letter encloses the arms of the Four Provinces of Ireland. *(Courtesy National Library of Ireland.)*

Limerick in the 1860s, and the discovery of the Tara Brooch increased interest in 'Celtic' objects. The Tara Brooch was not, in fact, found at the ancient royal site but at some distance away on a beach near Bettystown, County Meath. Naming it the 'Tara' Brooch gave it romantic associations in keeping with the spirit of the times.

All things Celtic were fashionable. Silversmiths and jewellers worked with 'Celtic' designs similar to those on the Ardagh Chalice and other Celtic metalwork. The founding of the Gaelic League, and the plays of Yeats and Lady Gregory were all part of the same cultural reawakening. (It was at this time that the shamrock and the harp became rooted in the national consciousness, even though they were quite new in the cultural repertoire.)

The art of the Revival, as this movement was called, gained great momentum from the Arts and Crafts movement that had been founded in England in 1894, and for decades the Catholic Church in Ireland commissioned much of the art produced. The extent to which the Church was a major patron of these works is shown by Loughrea Cathedral in County Galway, for instance, and the Honan Chapel in Cork, both of which are treasure-houses of the art produced in the early decades of the twentieth century. Meanwhile, the artist Sarah Purser set up An Túr Gloine (the Glass

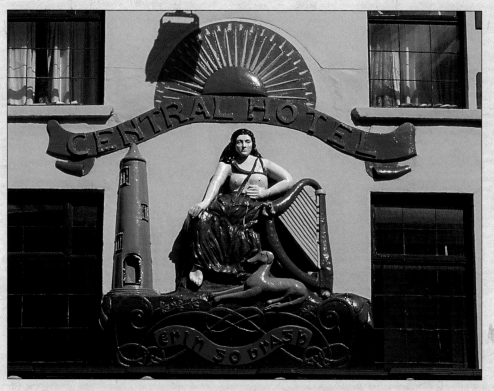

This colourful mural on the façade of a hotel in Listowel, County Kerry, features the popular emblems which were current in the 19ᵗʰ century. (*Photograph: Michael Diggin.*)

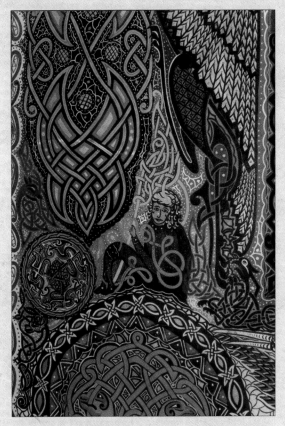

Tower), where artists could be trained in the techniques of stained glass; and the Yeats sisters' Dún Emer Guild produced Celtic embroidery, printing and tapestry.

One of the most remarkable examples of the art of this cultural era, and one of the last, must be the stencilled decoration that covers the walls of an oratory in the former Dominican convent in Dún Laoghaire, County Dublin. Inspired by the Book of Kells, it was painted by Sister Concepta Lynch OP between 1920 and 1936.

The art of the Revival ran its course. Once Independence had been achieved, the Revival had lost one of its *raisons d'être*, but the Celtic past that inspired it still has the power to inspire us. The ancient festivals, music, storytelling – and, of course, art – are being renewed and revisited today as they have been many times before in our history. In the following pages a modern artist, Deborah O'Brien, interprets and recreates in the light of that ancient inspiration.

Above and below: The art of the Celtic Revival saw its final flourish in the rendering of themes from the Book of Kells in an oratory in Dún Laoghaire, the work of Sister Concepta Lynch OP.
(*Courtesy Dún Laoghaire–Rathdown County Council.*)

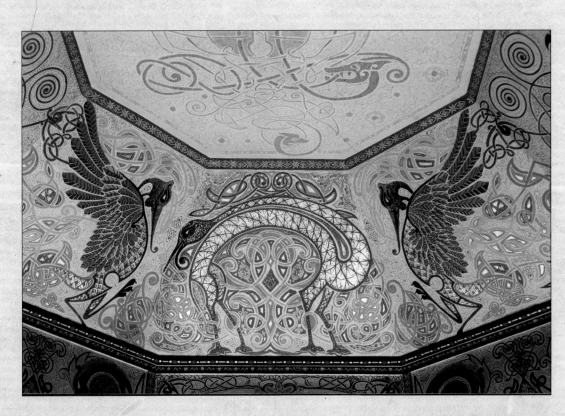

PART II

Introduction by
Deborah O'Brien

I knew the stars, the flowers and the birds,
The grey and wintry sides of many glens,
And did but half remember human words,
In converse with the mountains, moors and fens ...
JM Synge

Growing up in Ireland I absorbed the psyche of the land. My introspective, poetic and visual pulses were fed by the landscape and by the endless weather changes that can take place in a single day. The light is golden, the rainbows gloriously abundant and the land seems to live and remember in a melancholic sort of way. Paying homage to the ancient sites of Newgrange, Dowth and Tara, as well as holy wells, standing stones, High Crosses and earth mounds was part of many a journey. I found a oneness in those places, a space to be alone with myself. Later I familiarized myself with the Book of Kells and other Irish art treasures, and I found myself captivated by the rich intricacy of their craftwork. As WH Hudson says: 'Every feature of the landscape, everything that we see, hear, smell and feel, enters not into the body alone, but into the soul and helps to shape and colour it'. This absorption process laid a foundation stone for this work.

Other foundations were laid during my student years. When I studied the craft of fabric printing I learned the skill of repeat pattern, an essential technique when structuring Celtic design. I researched the decorative art of other civilizations, such as that of the native North Americans, and my favourite graphic art projects were those that incorporated the designing of symbols. During my teacher-training year it became obvious to me that colour was not a subject to be approached solely using scientific measurement – the teaching method of the day. Instead I found that colour was energetic matter and subject to the law of relativity. I will never forget

that 'bolt out of the blue' moment when I realized that colour was *alive*! This experience totally transformed my visual perception. With the influence of the land, my Celtic heritage, my study of pattern, decoration, symbol and colour, my creative toolbox was starting to fill.

The tradition of extensive surface decoration did not flourish as much in Ireland as it did in other countries where buildings, fabrics, carpets and ceramics are adorned with an abundance of pattern that is awesome to behold. Yet what decorative work remains from our predecessors has certainly created a great pride in things Irish and Celtic.

When I look at Celtic artefacts, one of the main qualities that shines through is the use of symbols. Symbols talk to that part of us that instinctually understands there is a deeper meaning to life, something transcendent that cannot be brought fully into words. As with other ancient peoples, the symbolic language of the Celts came from their observations of the natural world. It reflected their understanding of themselves and of creation. As Carl Jung said, 'Because there are innumerable things beyond the range of human understanding, we constantly use symbolic terms to represent concepts that we cannot define or fully comprehend'.

The element of infinity is ever-present in Celtic art, and a well-known symbol that embodies this is called the trefoil (pages 43; 75). It has a never-ending line and is the symbol of Bridget, the sublime one, she is the triune goddess: maiden, mother and wise woman. The spiral is another familiar symbol in Celtic art and has been used since Palaeolithic times. In nature, it is seen in the ripples of water, rings of a tree, fingerprints, ears, and snail shells. It symbolizes power waiting to unfold and the great creative force of increase and decrease.

At the onset of creating these designs I resisted the impulse merely to copy from the old magnificent manuscripts, such as the Book of Kells, the Book of Durrow and the Lindisfarne Gospels. After all, these were crafted by individuals whose style was as unique to them as handwriting is to us all. While working, I also came to understand and appreciate why it was monks who created these masterpieces: I feel that they come from a place of great contemplation and stillness, of meditation, and that that quality is their main gift to us.

Like many people today I meditate – I find the connection to higher and inner dynamics has enabled me to find those states within myself that otherwise may have lain dormant. Accessing these states is essential to my relationship with Celtic art. I find I can come back with the symbolic freshly held and allow the Celtic line to flow and the design weave itself into form. I love the sense of being connected to an

ancient tradition, to a line of souls in love with something nameless. It is as if one steps into the timeless where the days pass, and the joy of doing and seeing the work unfold is all that matters. As Rumi has said: 'Time does not know the nature of timelessness, because only wonder can lead to it'.

There were a variety of important elements in Celtic life: moon, tree, water. When I learnt that the Celts honoured the phases of the moon and that their month had 28 days, memories of hours spent loving the full moon as she shone on the waters of Dublin Bay or the Atlantic in County Clare came flooding back. I looked at her roundness, delighting at her light reflecting on water and the splendour of her illumination of the sky. At the same time in my life, I was making an in-depth study of basic shape, and that research brought me to sacred geometry, and I started looking at the ground plans of temples and churches. Their symmetry, balance, simplicity and complexity of form were beautiful. The grounded and transcendent qualities that I found in them gave me a deeper, higher, more esoteric understanding of shape. I noted then that what I found is at the root of many civilizations and religions, and it became essential from that point to adhere to those ethics of balance that are fundamental to the art of decoration.

I have always had a special relationship with trees. As a child, my relationship with them was mainly tactile – climbing them and using their branches for bows, arrows and catapults – standing high up in a big tree was always a very expansive experience! As an adult, I closely observed trees. I would go up to the Dublin mountains, down into the Wicklow valleys or visit Phoenix Park to absorb and photograph their splendour. Some time later, when I worked on the Celtic calendar, a friend introduced me to John O'Mara who supplied well-researched material about the Celtic year from his unpublished manuscript, *An Leabhar Céille – The Book of Common Sense*. I learnt that trees have a special place in the calendar, that they played a large part in daily and religious life and that they were used as emblems for most of the months. I have created designs in this book that are decorated with tree imagery, including rowan, hazel, elder and, of course, the sacred oak. The principle Celtic sacred tree is the oak, and it is also associated with St Bridget. That information resonated deeply within me and connected me to my roots in a way that something about myself was understood.

What I love about having been reared in Ireland is that myth is very much alive. The old stories are taught in schools and are familiar to most people, and it is these old legends that inspired some of my animal designs, such as Dog (page 42), Swan (page 62) and Salmon (page 66). I felt it was also important to keep with the

tradition of incorporating animal imagery, since ancient Celtic art is so rich with it.

I believe that animals have archetypal energies. The dog, for example, is a symbol for our instinctual nature, is a protector and friend. In Celtic mythology, dogs are often companions to heroes and war gods; they accompany Nodens, a god of healing. Dog (page 42) was inspired by the story of the superhero Cúchulainn, who changed his name from Setanta when he slew the hound of Culainn and vowed to act as his hound instead.

Swans symbolize the higher divine aspects of the self. They are wonderful, powerful and graceful creatures. The story behind Swan (page 62) was inspired by the tragic tale of the Children of Lir, who were turned into swans for 900 years by their cruel stepmother, Aoife.

Birds are portrayed a lot in the old manuscripts: they are the messengers of the gods and symbolize transformation. They are a wonderful image to work with because of the numerous ways they can be coloured. My picture of Geese (page 30) was inspired by the knowledge that the wild goose is a bird of heaven, bearer of good tidings and symbol of the winds.

In myth and island life, water and wind also play an important part. There are stories of gods being carried by the winds and heroes transported by it to Tír na nÓg – the Land of Youth, which lies beyond the sea. Niamh, daughter of the sea god Manannán enchanted Oisín the son of Fionn Mac Cumhall, they fell in love and she carried him far away over the sea where they lived together for centuries. I have spent a great deal of time by the sea; for hours I have watched the Atlantic winds lift the water into great waves and sweep them to the shore or crash them against the cliffs. Feeling the rushing air brushing against my face on a sunny morning or a cold grey day can be an all-consuming experience. I have often felt that for island people the sea and winds become part of the heart and blood.

I feel that one important contributory factor to the creative journey is ancestor memory – in my case, the link I have with my paternal ancestors. There are my Russian-Jewish ones, whose experiences have conditioned me to be passionate about what I am doing, to appreciate the beautiful and to keep going no matter what – so surrendering to the hard work of creating Celtic art is not difficult for me. In addition, my Irish ancestry has opened me to the poetic and the mystical. I feel honoured to work with my Celtic heritage and appreciate that the blood of the Celts flows strongly through Irish hearts. I am proud to know that as a people, although overshadowed for a time, we never forgot our roots. Both my cultures have given me the strength to keep my relationship with myself true.

I draw by hand and seldom use mechanical instruments. Acrylic is my medium of choice and is applied creamy layer upon layer until it binds together to create a depth of surface that builds up like tempera. When I weave in the ancient symbols, I feel like I am weaving in gifts from heaven. While working, I practice keeping the doorway to the unexpected open, and this makes all the stages of the work alive and fresh.

Trusting the process is an essential part of the dance of creativity. There is no fixed starting point – or if there is, it is the point of inspiration and then bringing that into form. Generally the patterns start from one single shape and build up to a fuller image. It is almost mathematical in that the shape may be repeated, dissected, added to or subtracted from, and this allows creativity to keep flowing and a balance of form to take shape. I am often so in awe watching the pattern unfold out of nowhere that I can feel my heart singing.

When I reflect upon my journey in life, my creative pursuits and my inquiry into the mystery of being human, I see a thread that weaves each chapter of my life together. When I look at the expression of Celtic and other decorative traditions I see a constant and universal thread that joins them. I do not have adequate words to say much about this thread that creates and instils wonder, harmony, balance, beauty, meaning and stillness. All I can say is that as an artist I have been deeply touched and honoured to have been shown a doorway that has allowed me a glimpse of the vastness that is within the Celtic tradition, I am grateful to have been touched and embraced by its soul that inspires and creates its form.

Oak

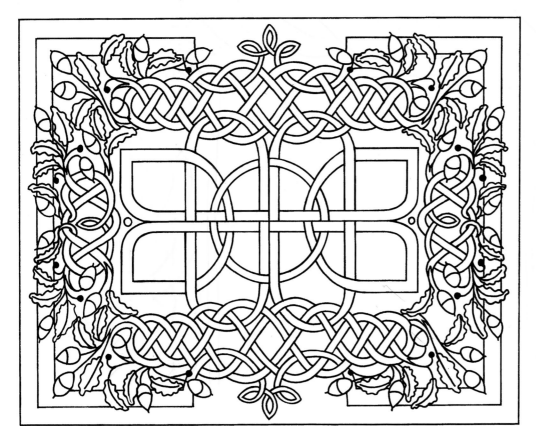

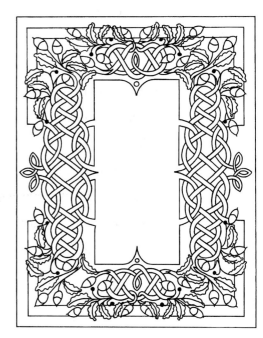

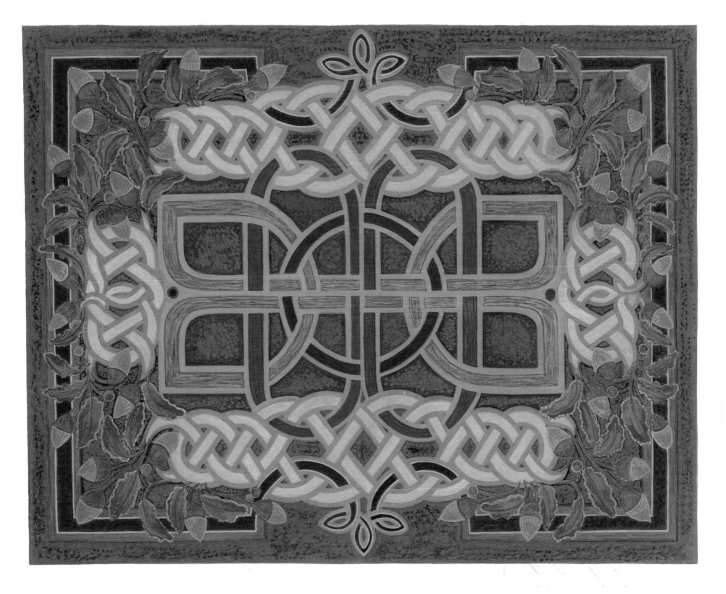

THE OAK HAS A SPECIAL PLACE in my heart. It symbolizes the mystic doorway; in the Celtic calendar it represents the seventh month of the year – the month of the all-important summer solstice. Because it can live for a thousand years, the oak was a symbol of strength to the Celts. Its wood was used in spiritual rites and its fruits and bark for healing. In my drawing, the golden yellow of the interlacing honours the mightiness of this tree, for gold is the supreme colour. The autumn rusts have the oak's feminine qualities, while the translucent blue holds and allows the majestic qualities of this wonderful tree to shine through. The vertical and horizontal lines of the central motif move like the seasons in endless motion, while the circle, which I see as the timeless mother, holds the central axis. The trine at the top and bottom symbolize divine sustenance from above and below.

Geese

THIS SIMPLE STYLE of interlacing border work has become prominent in Celtic art. Because it has no beginning and no end, interlacing is a symbol of infinity and is a main thread running throughout Celtic pattern. The gold and the blue is a striking combination and suits the subject well. The Celts associated geese with gods of war, and the use of gold here symbolizes this divine power. Meanwhile the blue waves represent those fathomless and boundless elements of transportation, water and air. The central image of the birds embracing has a simplicity that creates a harmonious and beautiful picture of union.

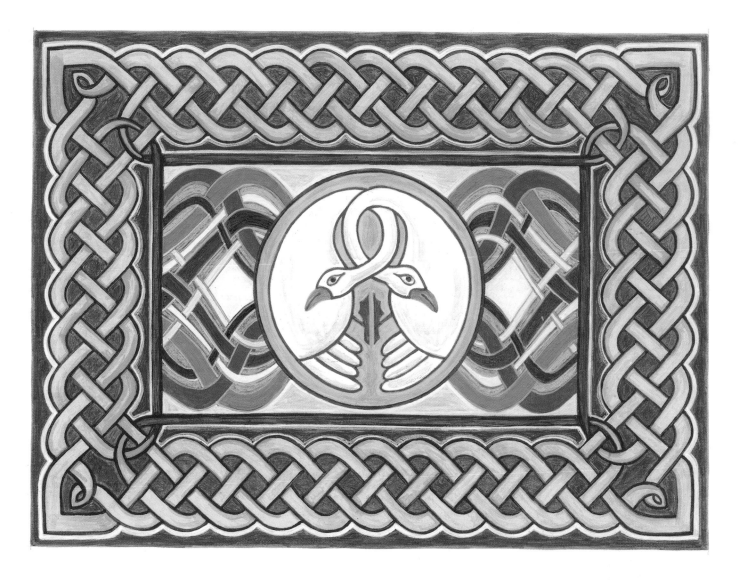

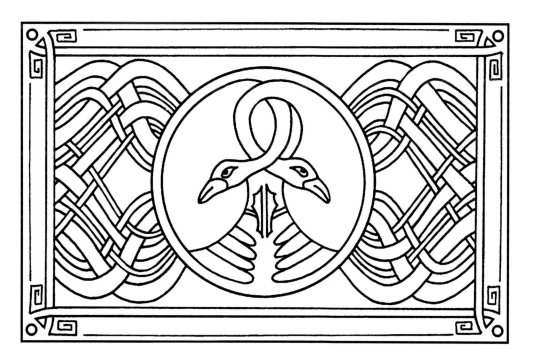

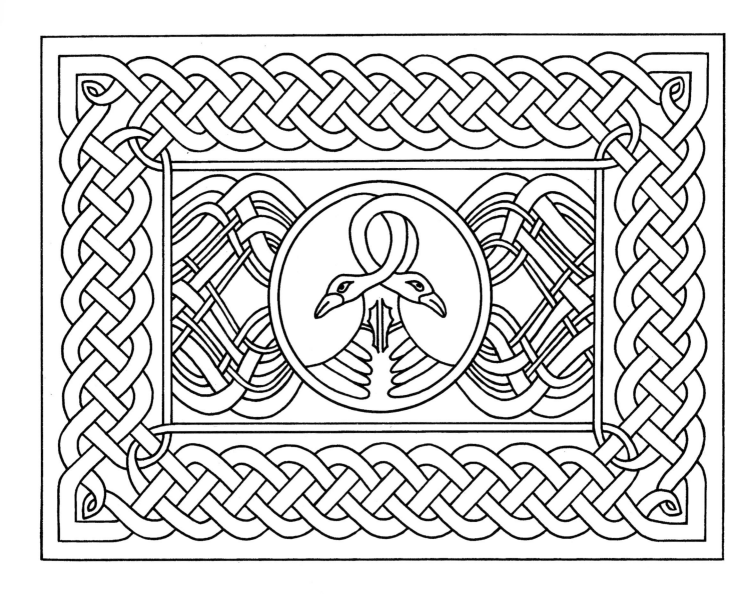

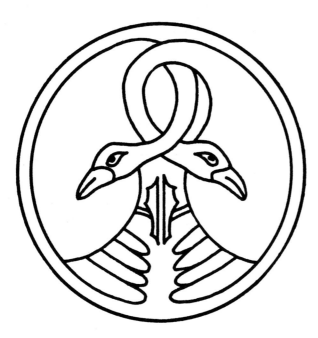

Hazel

THE CELTS HONOURED the hazel tree as the noble tree of wisdom and mystic inspiration. It was placed with the ninth month of their calendar year at the latter end of summer. Nine was a sacred and significant number for the Celts, associated with the Beltane fire rites and the great mother, Bridget. In myth, the hazel is said to have grown by the source of the waters of two of the great rivers of Erin – the Boyne and the Shannon – and also by the five rivers in the Land of Promise. Hazelnuts are said to have dropped into these rivers, thereby infusing the waters with great knowledge. This is why one magnificent salmon, who swam in these waters, became known as the Salmon of Knowledge (see Salmon, page 66). For the border of my drawing, I have chosen deep, quiet colours appropriate to the ninth month. I feel that the rich gold of the centre has a deep stillness that embodies the essential mystical and wisdom-giving properties of this tree.

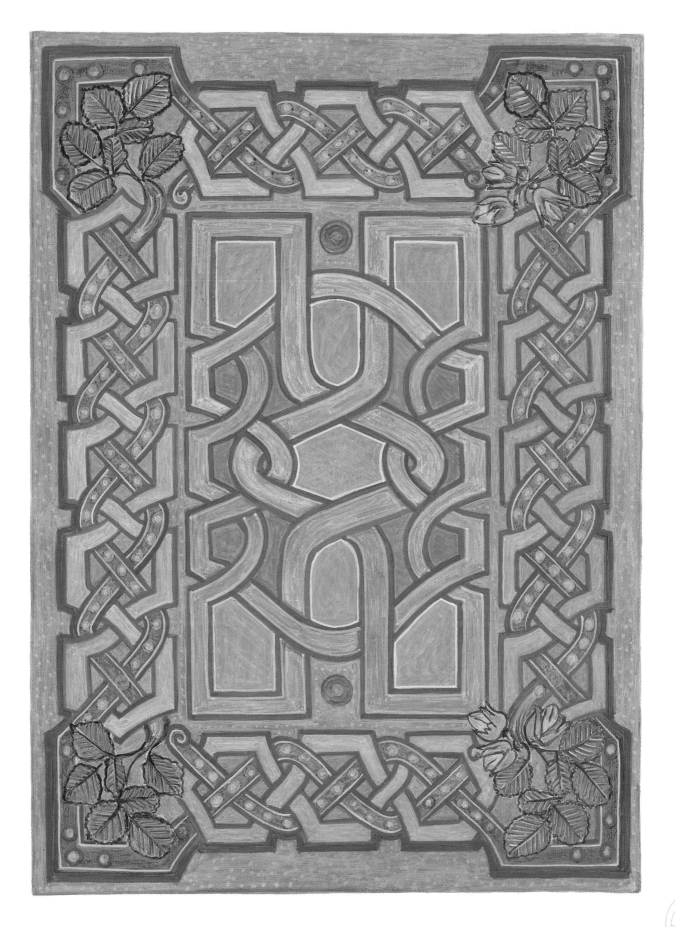

Birds

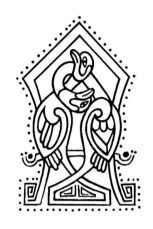

BIRDS ARE OFTEN PORTRAYED in ancient manuscripts as the messengers of the gods. They also symbolize transformation. The Celts felt it was possible to be able physically to change shape; in legend, heroes would shape-shift into birds to escape danger or fly to other lands. Birds symbolize humankind's aspiration to transcend. This design has a quality of strength – the deep-blue border gives the interlacing a stable, grounded presence. The central pattern of a cross intertwining with a circle is a symbol of totality, and the deep gold behind it gives it an almost cosmic quality.

Rowan

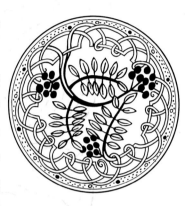

THE ROWAN TREE is sometimes called the 'Lady of the Mountain'. Its blossom is sacred to Bridget and it symbolizes poetic inspiration. Its forked branches can be used to divine water. The rowan is the tree of life and a protector, and was often planted near Celtic homes to guard them. Because of its fast growth, the Celts associated it with the passage of time. The border of my design has an energetic liveliness about it that honours the strong life force of this tree. The forward motion of the centrepiece chimes with this image. The changing colours on the people's garments symbolize change, while the significant number three symbolizes growth and forward movement.

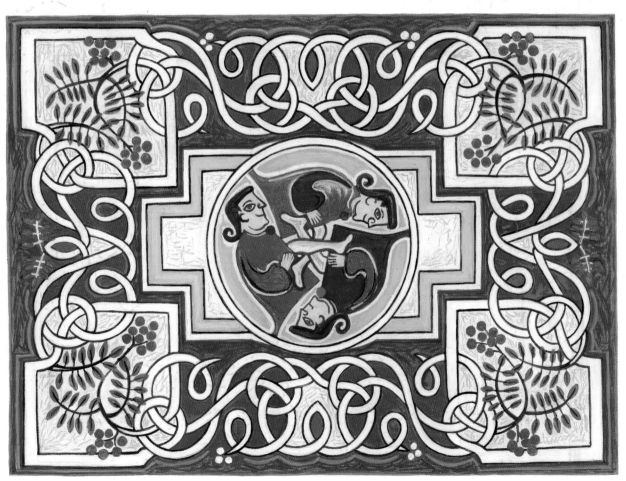

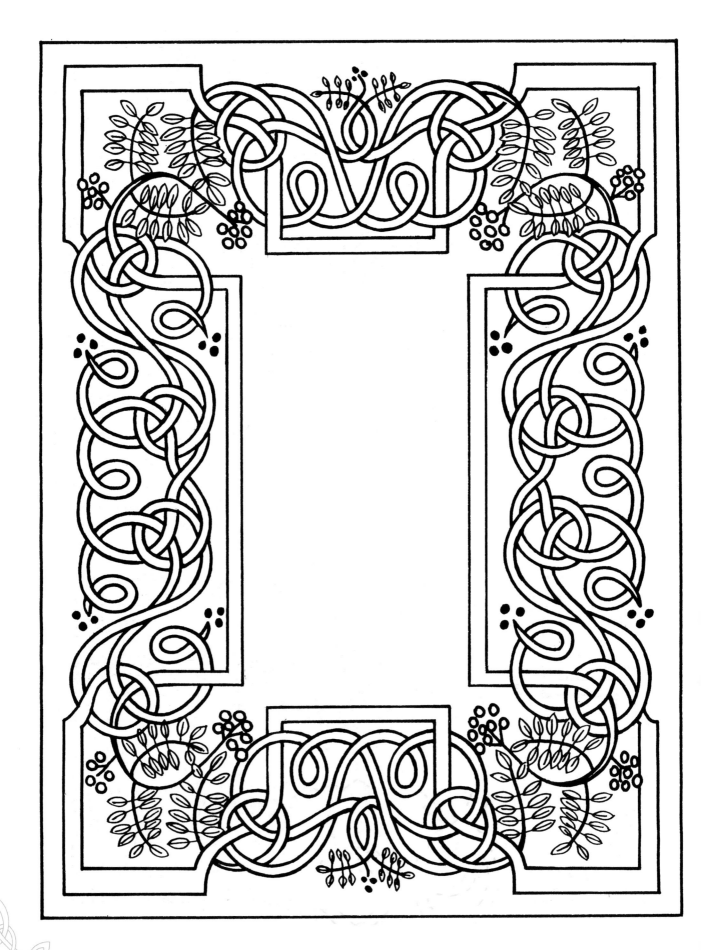

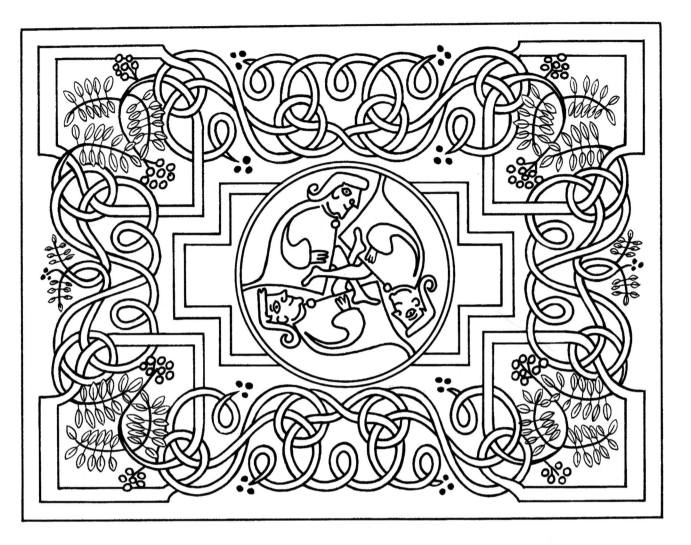

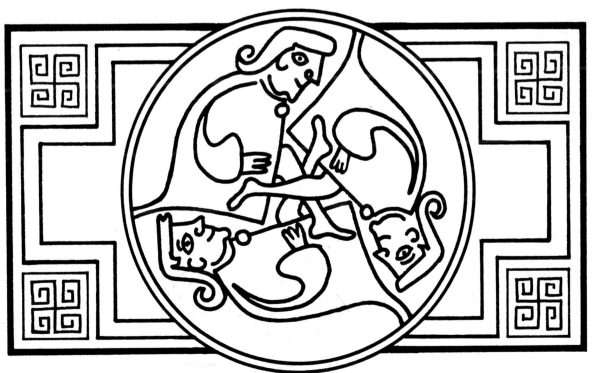

Dog

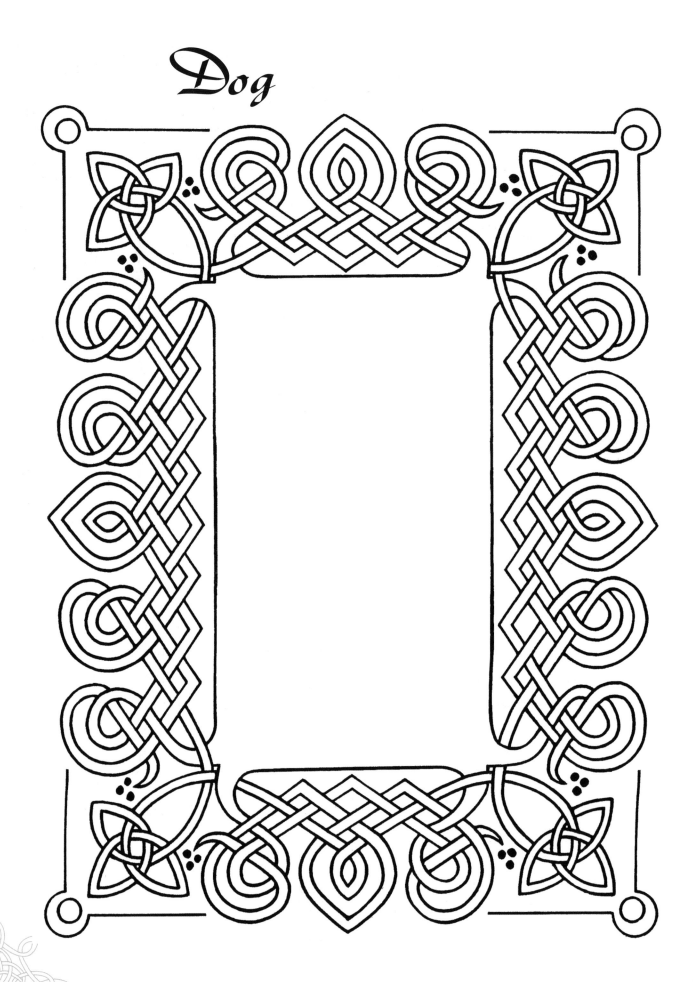

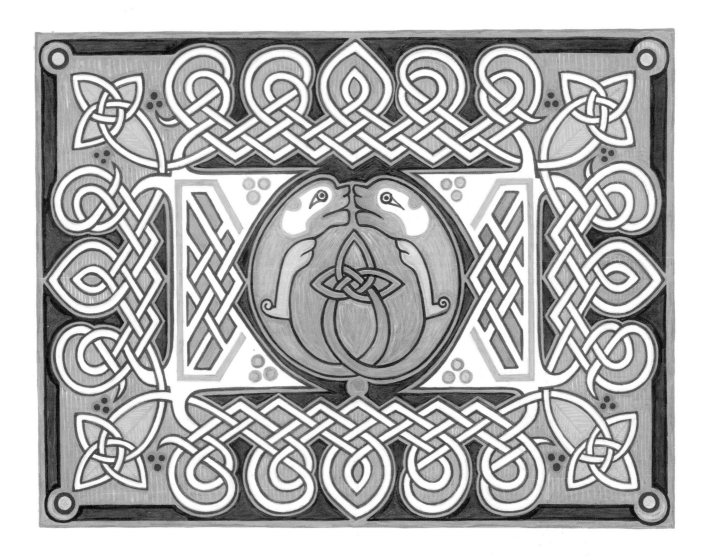

THE CELTS ASSOCIATED DOGS with gods of war and healing. Celtic heroes, such as Fionn Mac Cumhall, were often accompanied by favourite dogs with special powers. In my design, the generous shaping of the interlacing, the centrepiece and the colouring creates a contained, overall harmony. The colours have balance: gold and silver symbolize two aspects of the one reality, while purple and white represent glory and simplicity. The two animals together represent twofold strength, and these dogs merge beautifully into the trefoil, a symbol of the trinity, which gives this image a transformative quality. Quatrefoils are powerfully set at each corner. The quatrefoil, unlike the Christian trinity, incorporates space for a mother-figure, thus giving the symbol a different wholeness.

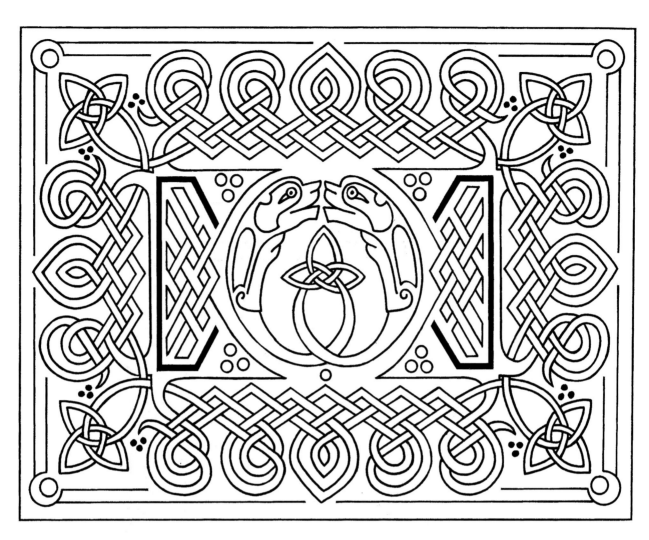

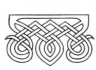

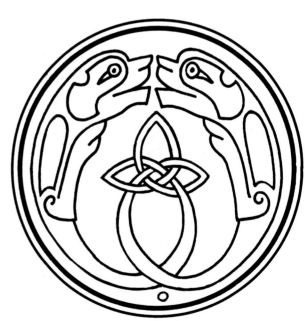

Interweaving

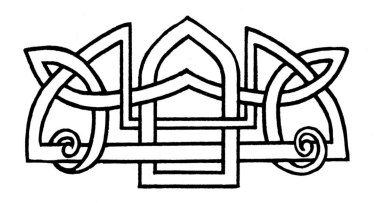

INTERWEAVING OR INTERLACING is the central form and axis of Celtic art. It is a hallmark, a constant and essential thread. Interweaving has a wealth of meaning: it can represent the in and out of the breath, the eternal warp and weft of life's tapestry and the ceaseless flow of movement. Knot-work, another common name used to describe it, never felt quite the right term to me, because I associate knots with constriction.

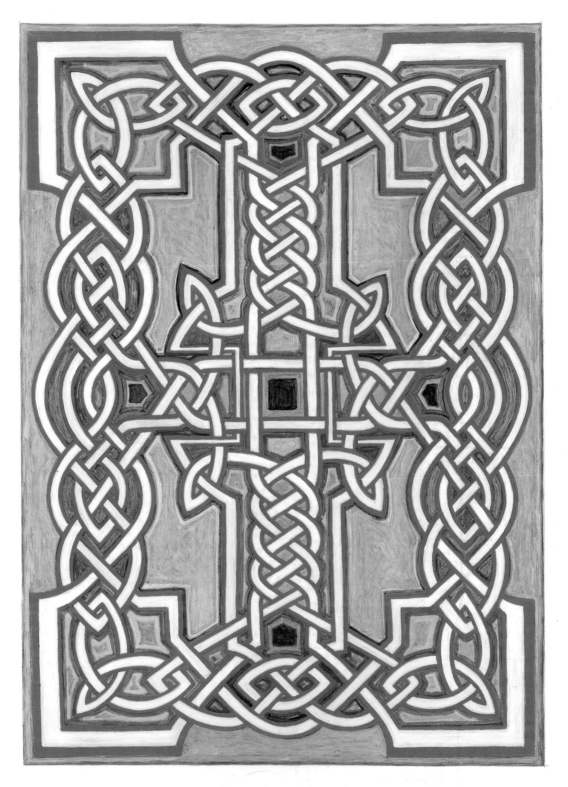

There are six threads in this design, six being the number of harmony and perfection. Interweaving is often described as a symbol of love and friendship, because the lines join and blend with countless meeting and farewell points. Many Celtic stone crosses have the cross within a circle, creating a powerful heart, but here, the overall image is a cross within a square – transforming this into a symbol of stability. The gold of the background holds this image like the Sun holds the Earth.

47

Cross

THIS PAINTING is full of power and meaning. The cross and spiral are the most ancient of symbols. Combined with the circle and square, these symbols are all-embracing. The cross is the union of Heaven and Earth, the infinite expansion of material and spiritual potential. The spiral is the creative force of life and death. It felt fitting to place these ancient symbols within the all-embracing circle and the containment of the square. The circle is fundamental in the shaping of Celtic art. It is wholeness, while the square is balance and integration. I feel the placing together of these elements creates a dynamic presence, while the colouring creates a cosmology. I have positioned the four orange circles between the cardinal points of the cross to increase its power still further. The deep blue-black of the interlacing, offset by the gold, evokes the strength of Mother Earth and consistency of Father Sun.

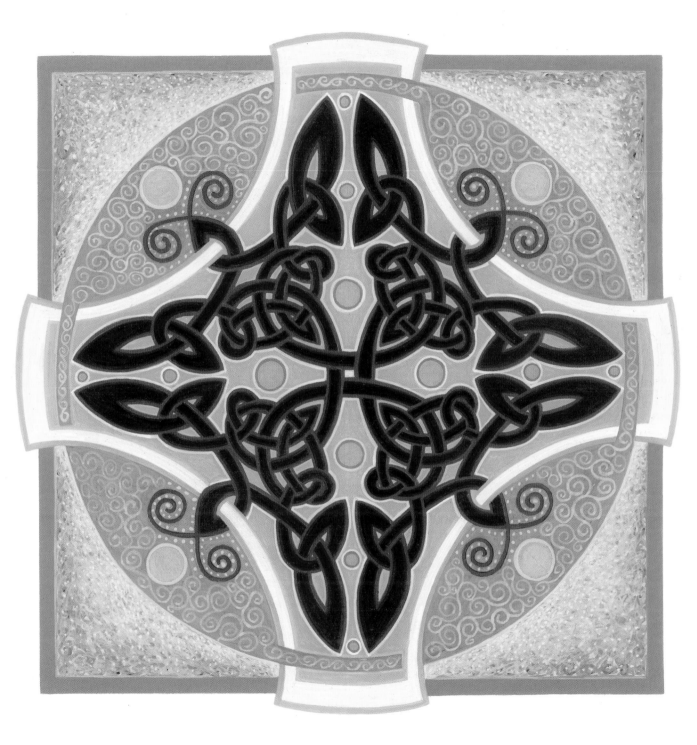

49

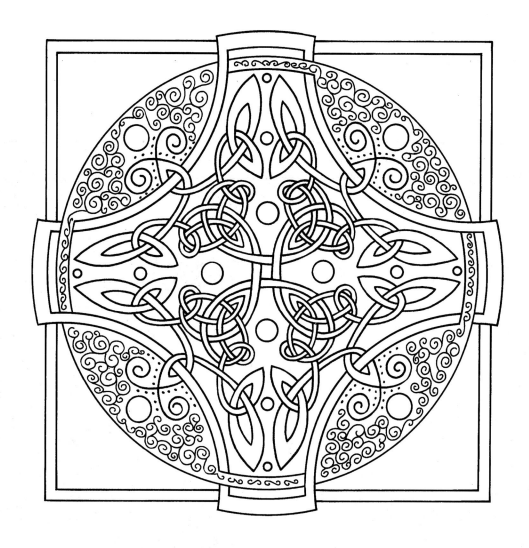

Elder

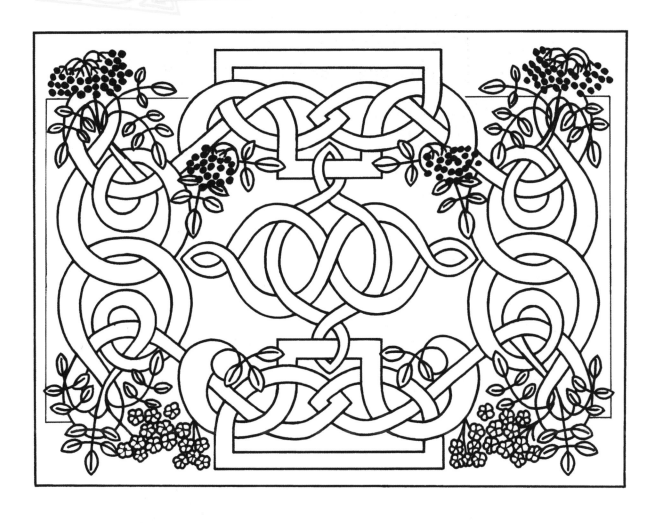

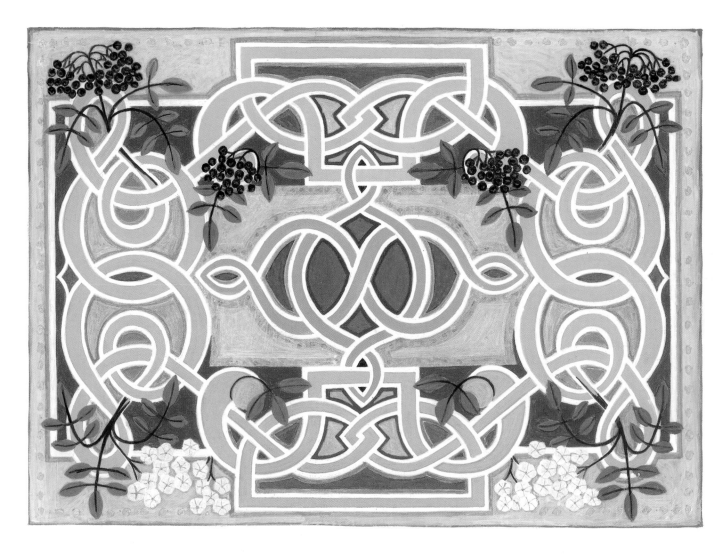

THE ELDER IS A SACRED TREE. Along with the hawthorn, it is home to the fairy folk. For the Celts, this tree was a symbol of death and rebirth. It was placed with the thirteenth month of their solar calendar, at the end of the old year and the beginning of the new. Midwinter was the time when the Sun god Lugh was born. A generous tree, the elder bears an abundance of flower and fruit – its medical properties are numerous. The juice of the red berries was especially sacred, and the Celtic priesthood drank it during the important winter solstice festivals to heighten their awareness. Nowadays, with some sugar, yeast, lemon and water, ripe elderberries can easily be made into delicious wine.

The Celts used the wood and foliage of the elder tree in religious ceremonies and for adornment at festive times. With its distinctively shaped flowers and red, red berries, it is always a delight to see. There is a fullness in this image, and in the roundness of the pattern. The richness of the red and the softness of the sandy shades are held together with the delicate green-blue of the border, to create a soft energetic dance.

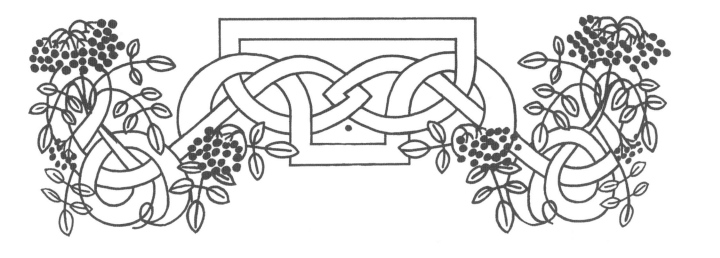

Fish, Bird, Dog

INITIALLY I CREATED AN IMAGE entitled 'three points', and I then developed it further to incorporate the significant animal forms of the fish, the bird and the dog. I wove these three images together to create the central pattern of this design, and I retained the three principal points. Three is a central number in Celtic spiritual life, and the three-point symbol of the triune goddess Bridget, the mother of creation, radiates from the centre. Water, air and earth are represented by the fish, bird and dog respectively, and the colours blue and green are symbolic of these elements. The fern, a plant that has its roots in prehistoric times, is placed at the base of the design and brings a sense of age.

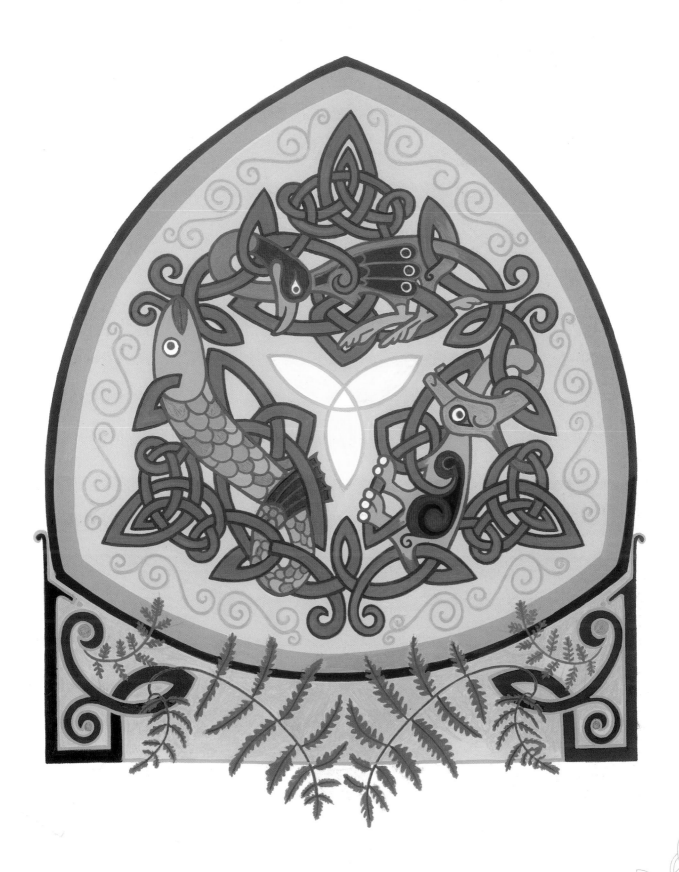

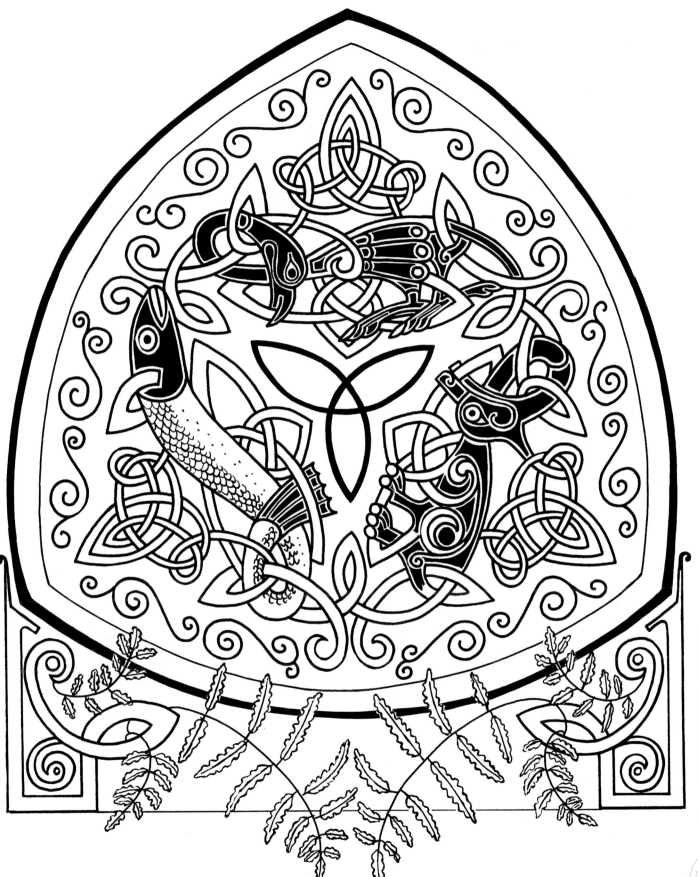

Golden Centre

THE GOLDEN CENTRE is an evocative piece of work. The wonderful contrast of colours certainly creates a powerful image. The night-time quality of the grey-blue creates a feeling of being in space, which is intensified when the red interlacing is superimposed upon it. The interlacing itself, both in the border and in the central pattern, carries a strong meaning of infinity. The disc of gold that holds the central pattern has an aura of power and an authority, and this contrasts pleasingly with the softly shaped parameter of the pattern, as it moves wonderfully into a strong focus towards the inner centre of whiteness.

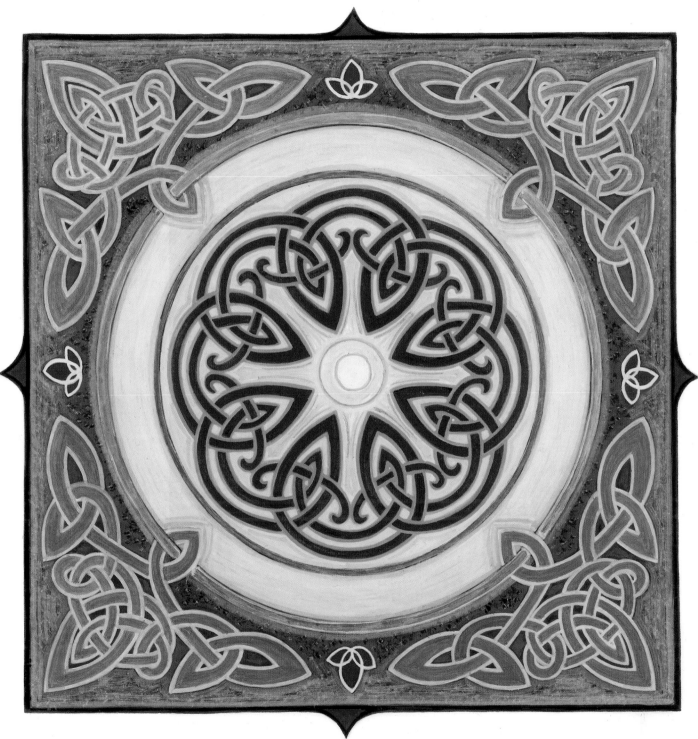

Four Directions

THE PATTERN OF INTERLACING in this design energetically moves and flows in one continuous line. When this characteristic of Celtic art is achieved, the thread of infinity is woven into the work. The focus of the eye changes easily, and finds many patterns here. A cross quietly shows its presence and is firmly fixed by the blue diamonds in yellow at the four cardinal points. The colours have a vibrant warmth and a touch of primary strength, which gives this design a feeling of sunshine and heat.

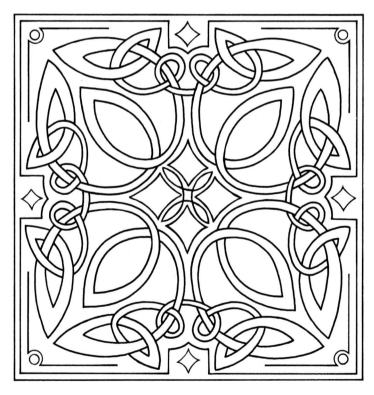

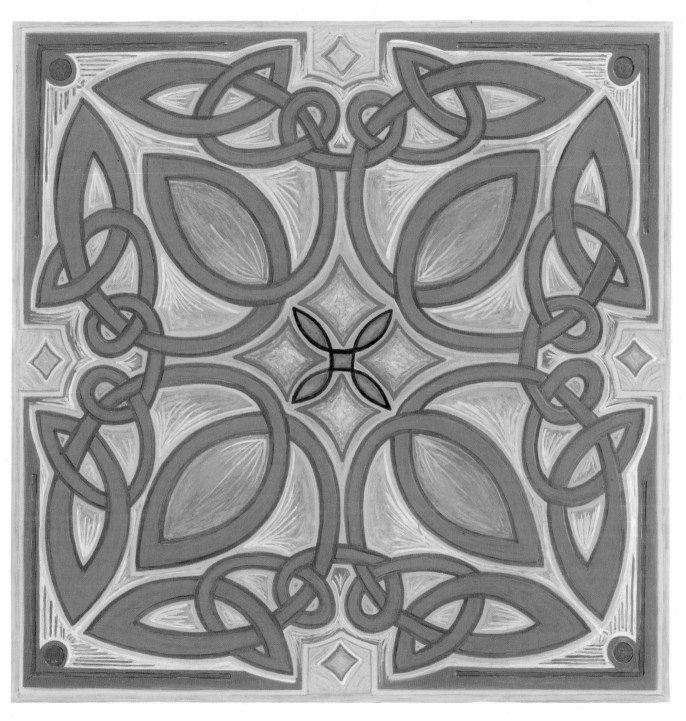

Swan

THE SWAN IS A REGAL CREATURE – a Celtic solar deity who possesses the healing powers of the waters and sun. Swans symbolize compassion, love, purity, sincerity and its dying song is the song of the poet. Swans are central to the tragic story of the Children of Lir, an ancient and well-loved Celtic myth. In it, a wicked stepmother, Aoife, is jealous of her four good and beautiful stepchildren. She curses them and consigns them to live as swans, buffeted on freezing lakes and seas, for 900 years. Their magnificent singing is their only consolation.

The diamond is a precious gem created out of roughness, symbolizing transformation, as well as incorruptibility, knowledge and truth. Together the swan and diamond make a fitting emblem for our nobler qualities.

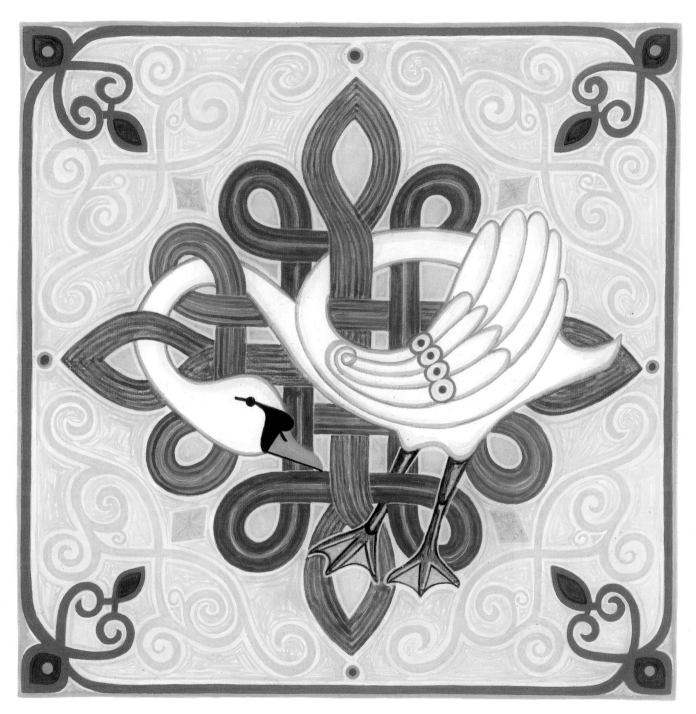

Three Birds

THE SACRED NUMBER THREE is here represented by the three birds and the central image of the trinity. Birds can represent divine manifestation and the human soul's ability to soar and transcend. The all-embracing feminine container that is the circle softly holds the image. Each bird shares the same colours but wears them in different ways. The gold of the background shines like the sun and the parameter of green and deep blue is like the body of Earth holding the manifest and the mysterious together.

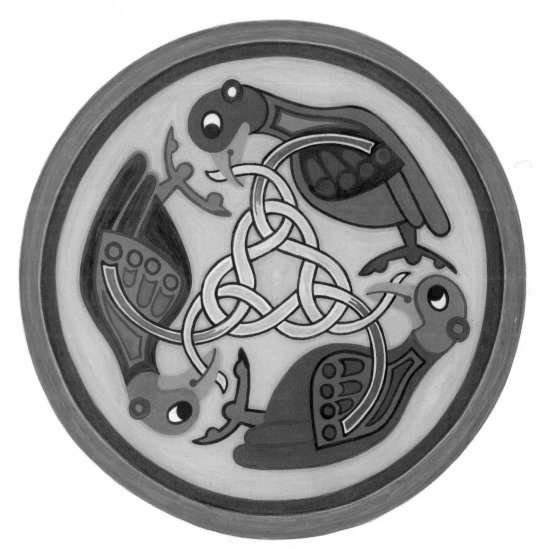

Salmon

IN CELTIC MYTH, the Salmon of Knowledge lived in a great river, whose waters were infused with wisdom. One day, the legendary hero Fionn Mac Cumhall caught the Salmon of Knowledge and, while cooking it, burned his finger on it. He stuck his thumb in his mouth and thereby immediately gained the salmon's wisdom. The noble creature here is entwined in a golden diamond, which is contained by a delicately coloured border and pattern. The colours I have chosen are significant: wisdom is golden, pink has a potent strength and the soft blues symbolize the great enfolding Mother.

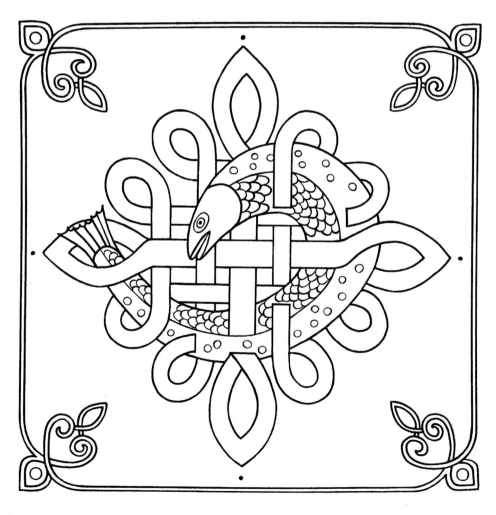

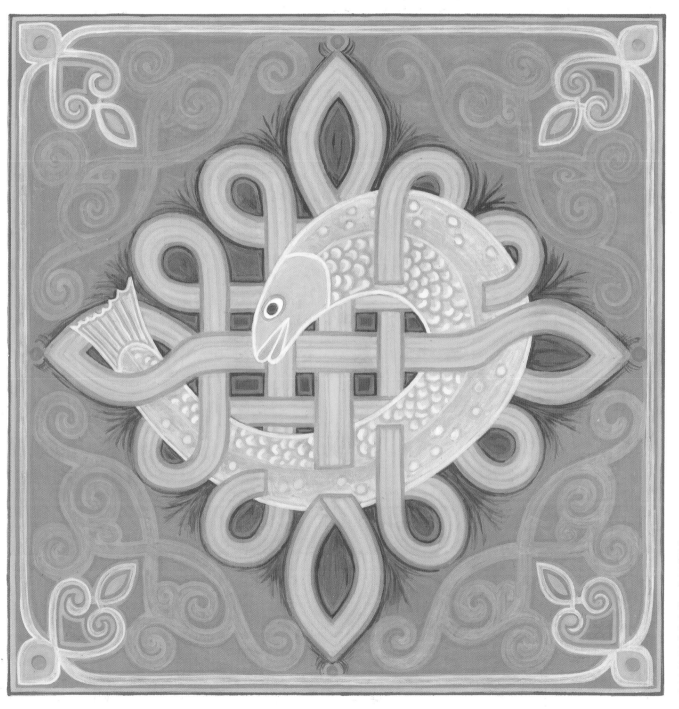

Flowering Diamond

IT IS SAID THAT PEOPLE are the crown of God's creation because, above all animal, mineral and vegetable life, they alone have the potential to be conscious. This piece could convey that thought. The flower symbolizes spiritual awakening, and the gold colour represents spiritual fire. Pink is the colour of love, and the diamond itself represents purity and light. The colours of the couple's garments also convey meaning: the woman's purple-pink represents the integration of power and love, while the man's blue is the Celtic colour representing the bard and the poet, and also stands for wisdom and consistency. The woman holds a quill, an instrument of communication, and the man and woman together hold the diamond, which is bursting into flower.

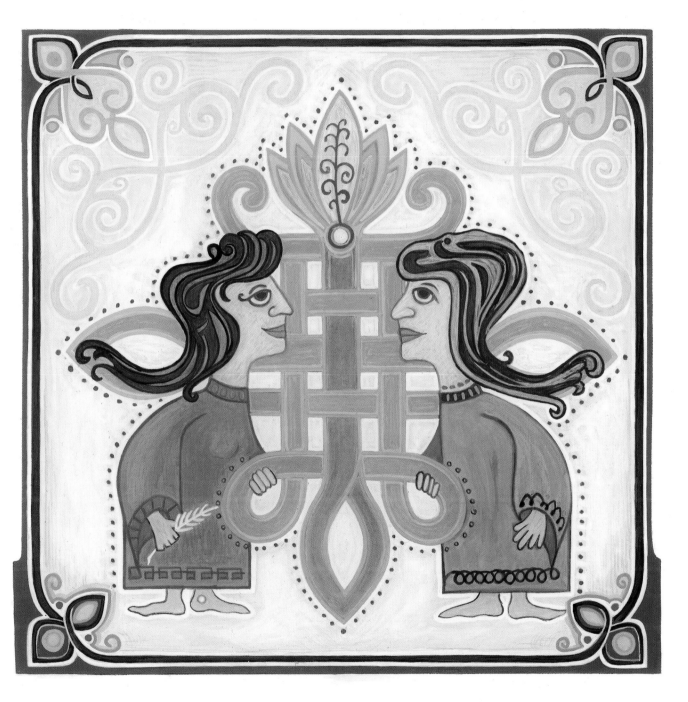

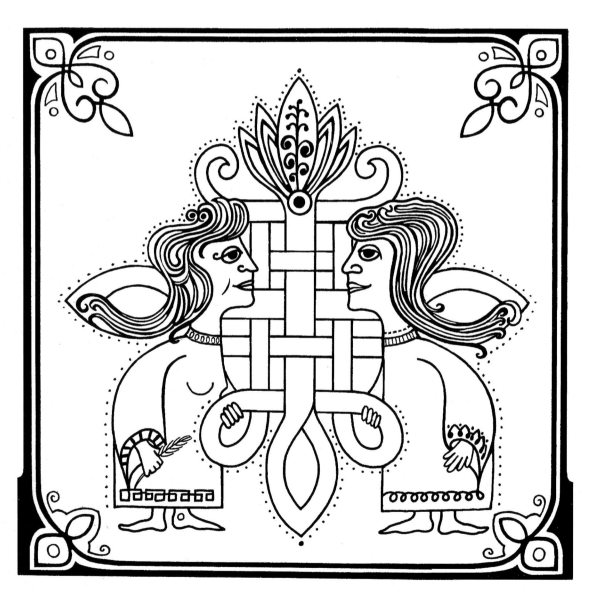

PART III

Practical Applications

Decorative features can enhance the simplicity or grandeur of your surroundings. You can create atmosphere in a room – or outside – with just one or two designs, or you can lavishly decorate your entire space. Since the possibility of decoration exists wherever there is a surface, the choice is endless. And because of the fluid nature of Celtic art, a design can be worked so that it fits the curves or lines of any home or working environment. Surfaces might include: furniture, window shutters, doors, frames, books, bags, cars, boats, lamp stands/shades, curtains, cushions, baths, arches, skirting boards and stairways. In the garden, you could decorate gate posts, fences, glass-houses, stone, sheds, walls, patio floors or flower pots.

The applications for Celtic designs are numerous and the techniques require varying skills to execute. Techniques can be learned from specialist craft books or through in-depth part- or full-time study. Stencilling and painting are two of the easier methods. Embroidery, batik, enamelling, making stained-glass, screen-painting and wood-carving are perhaps less easy to learn alone.

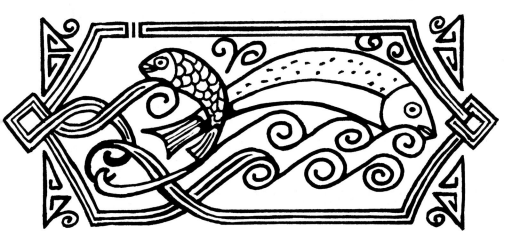

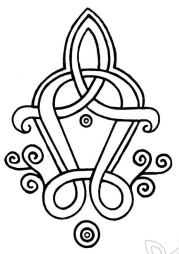

Diamonds and Squares

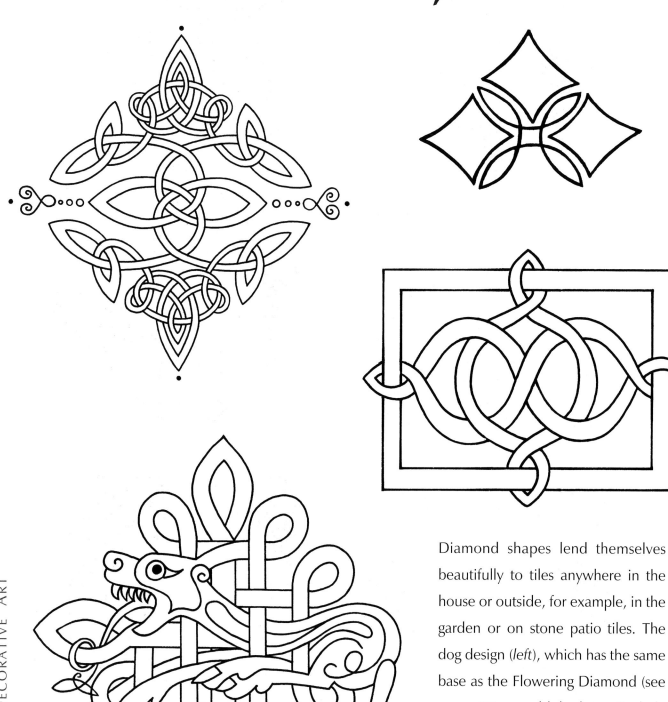

Diamond shapes lend themselves beautifully to tiles anywhere in the house or outside, for example, in the garden or on stone patio tiles. The dog design (*left*), which has the same base as the Flowering Diamond (see page 69), would look particularly effective as a tattoo, or perhaps to decorate a room with a Celtic or even a Chinese motif.

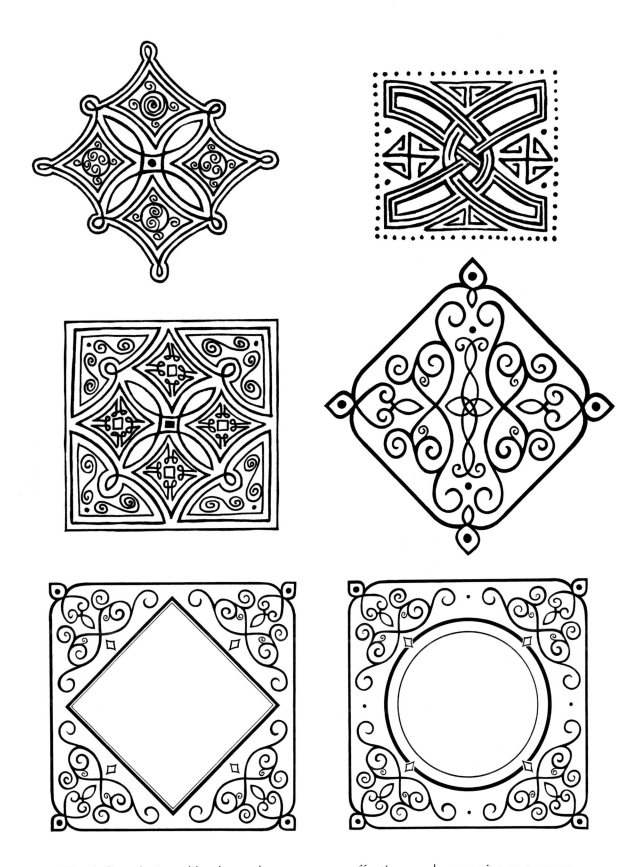

Simple line designs, like those above, are very effective on glass or mirrors, or as an inspiration for any kind of decorative wrought-iron work, such as for gates or balconies. You could also try using these for doilies, cushion covers or other soft furnishings, or even make a decorative clockface.

Rectangles, Corners and Borders

Rectangular shapes are great for larger projects, such as bedspreads, floors, rugs, borders, tabletops and doors. The simpler ones on pages 76–77 can also be used for smaller projects, such as towels, cupboards, drawer fronts, stationery and bookplates.

The trefoils and quatrefoils (*opposite*) are especially good for decorating corners. You can use all these designs for smaller items, such as leather bookcovers, brass nameplates, the tops of a boxes, stationery, the corners of window blinds. They can also be adapted for larger ideas, such as floors, skirting boards, picture rails, walls, panelling, window recesses, the space above doors and so on.

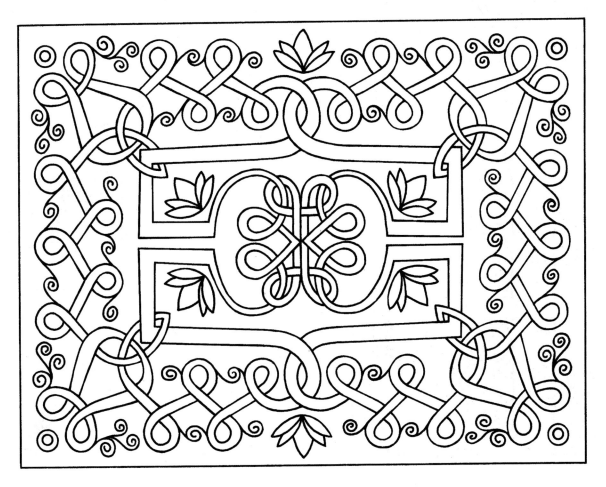

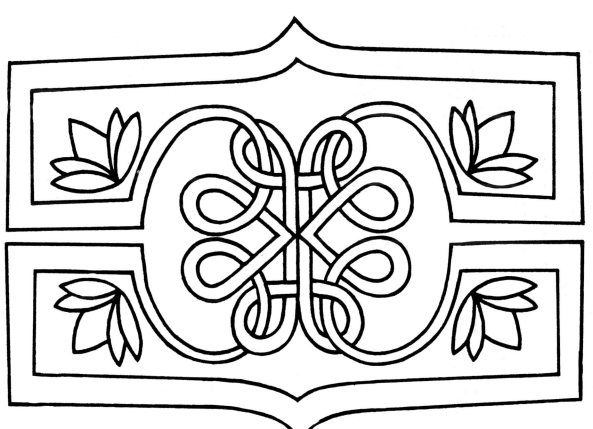

Circles

Circular designs are great for decorating objects such as tabletops, chair backs, lampshades, drawer fronts and the sides of furniture. The designs opposite would be stunning as the basis for a stained-glass window design. Try using them also for other smaller items, such as jewellery, certificates, tiles and the lids of tins.

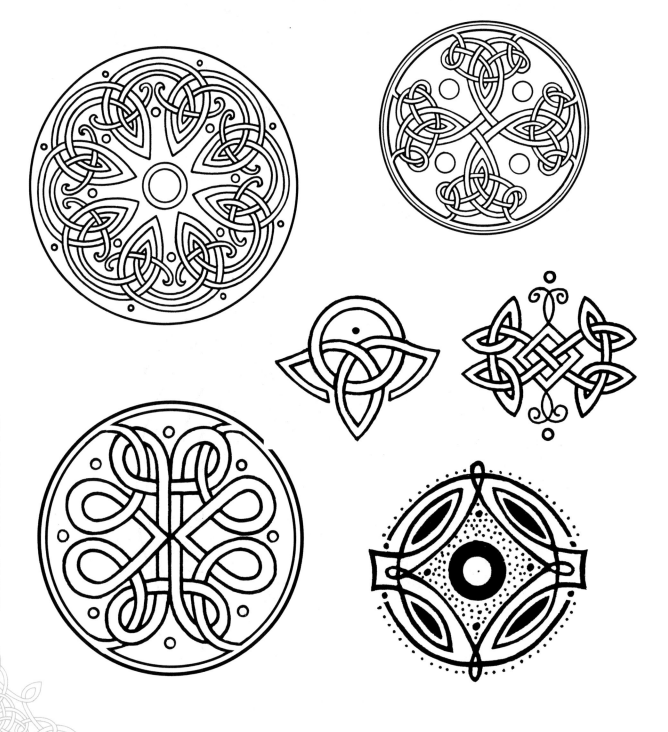

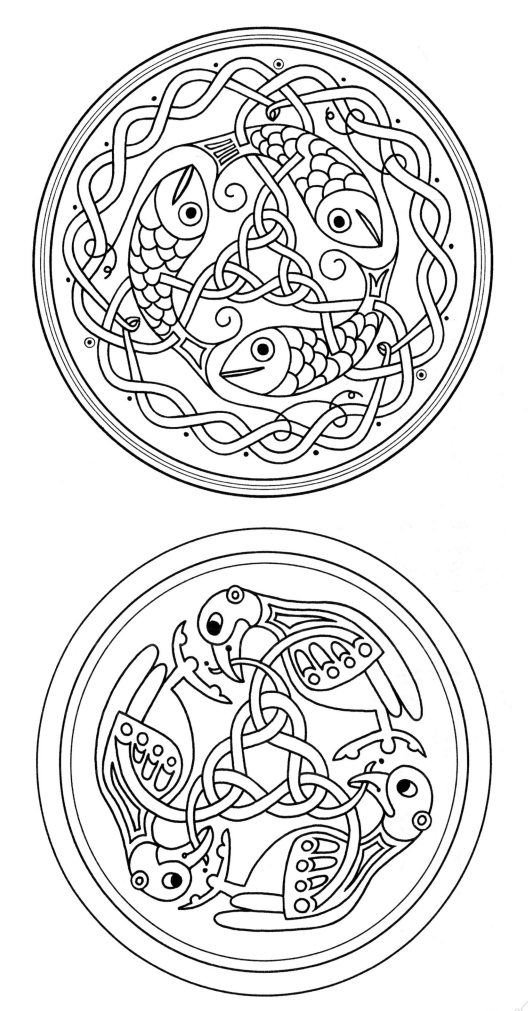

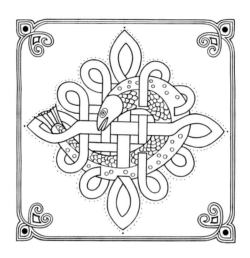